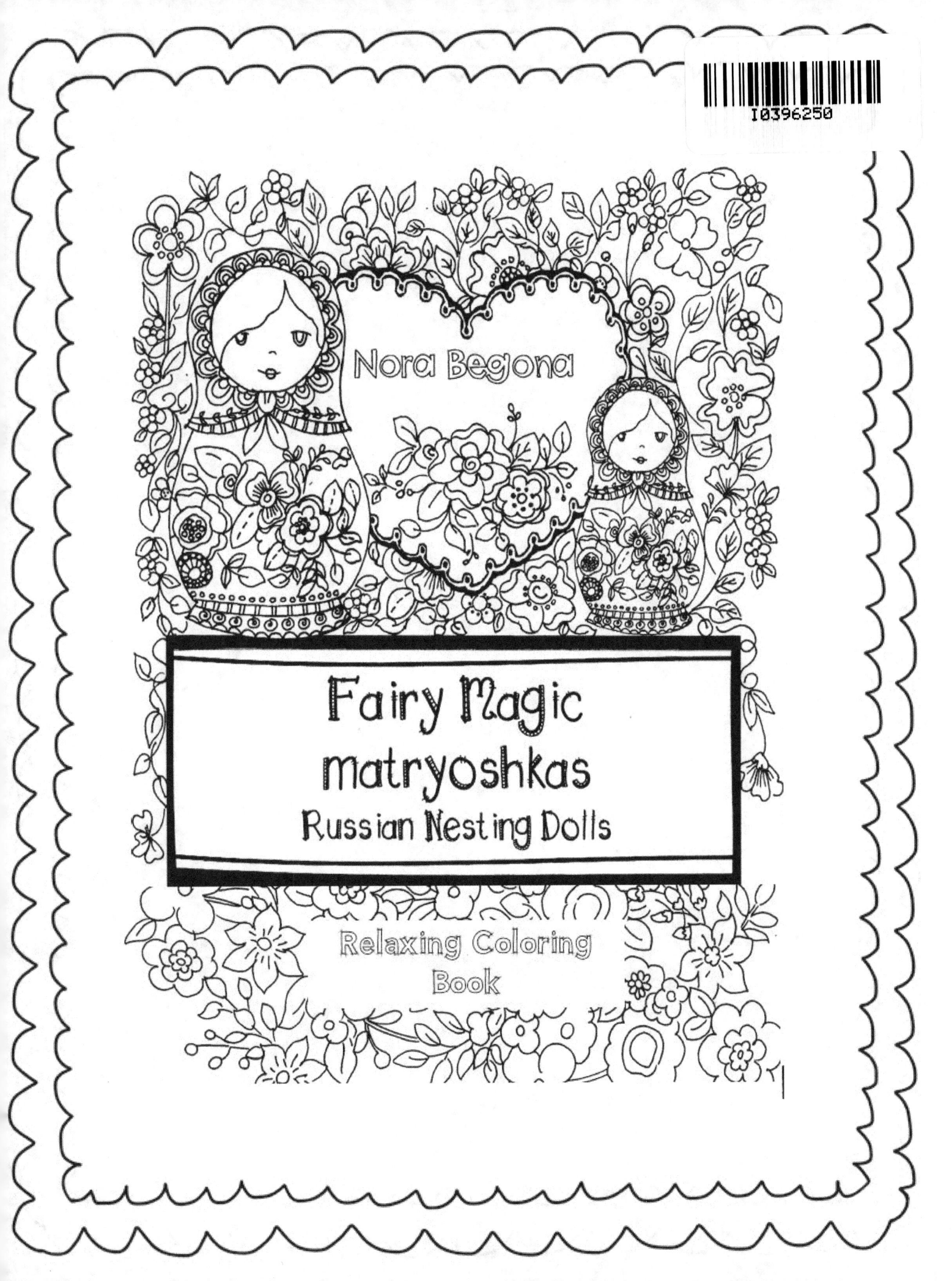

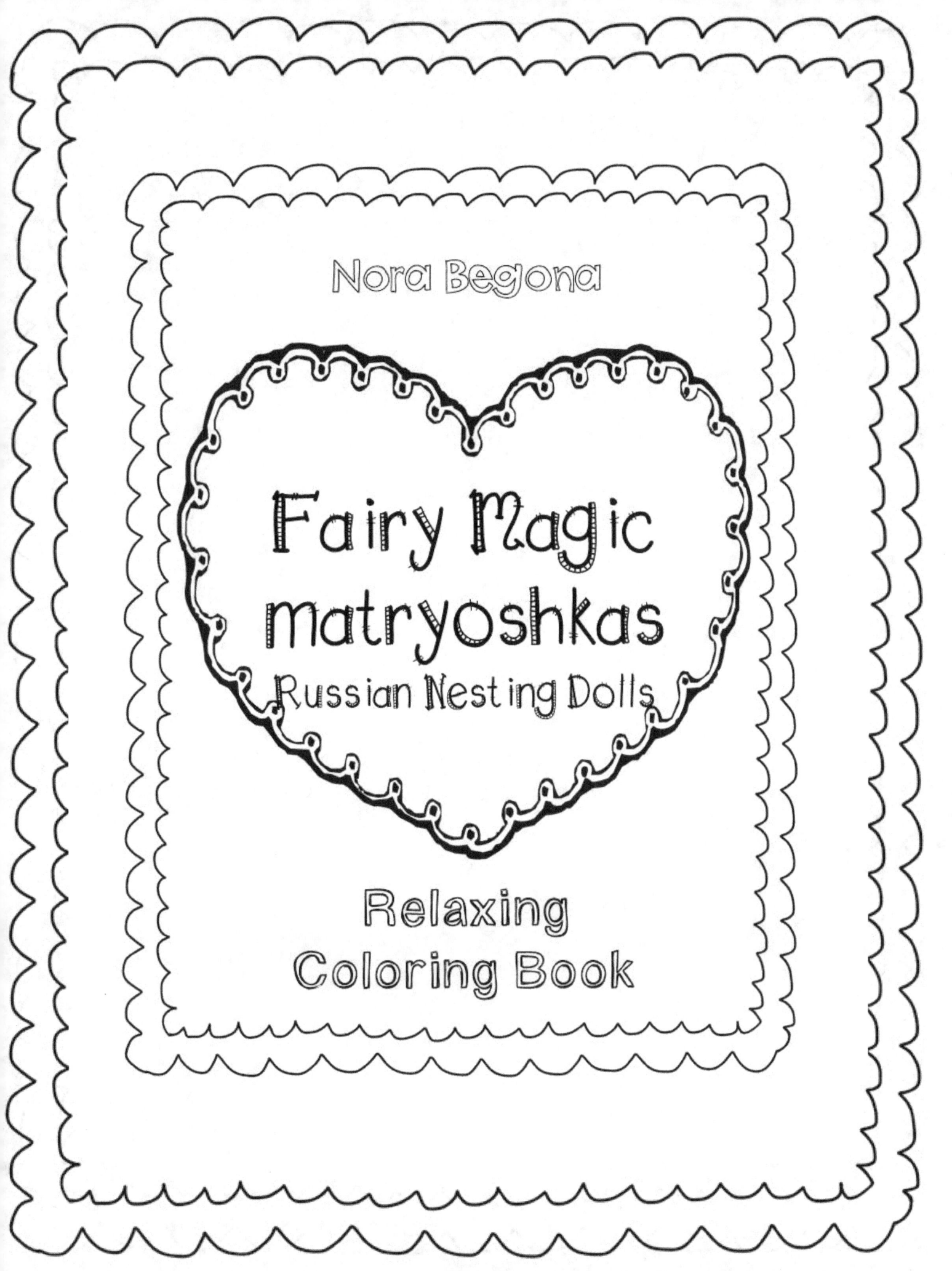

Copyright © 2015 by Nora Begona

All rights reserved. This book or any portion there of may not be reproduced or used in any manner whatsoever without the express written permission of the publisher
except for the use of brief quotations in a book review.

Printed in the United States of America
First Printing, 2015

The 3Hares Castle Publishing
Houston- Buenos Aires

Welcome to my Magic World of Ink Black Doodling.

Inside the book you will find intricate drawings for you to color. You will also have space to create your own drawings, enhance the ones I made, and Design your own nesting dolls. I have included templates for you to draw and color.
This book will let you relax, have sometime for yourself, and you will see how much peace in will bring to you.
Play some soft music, grab a cup of tea or coffee, and get enchanted by the magic of this treasure.

Believe and Enjoy!

Nora

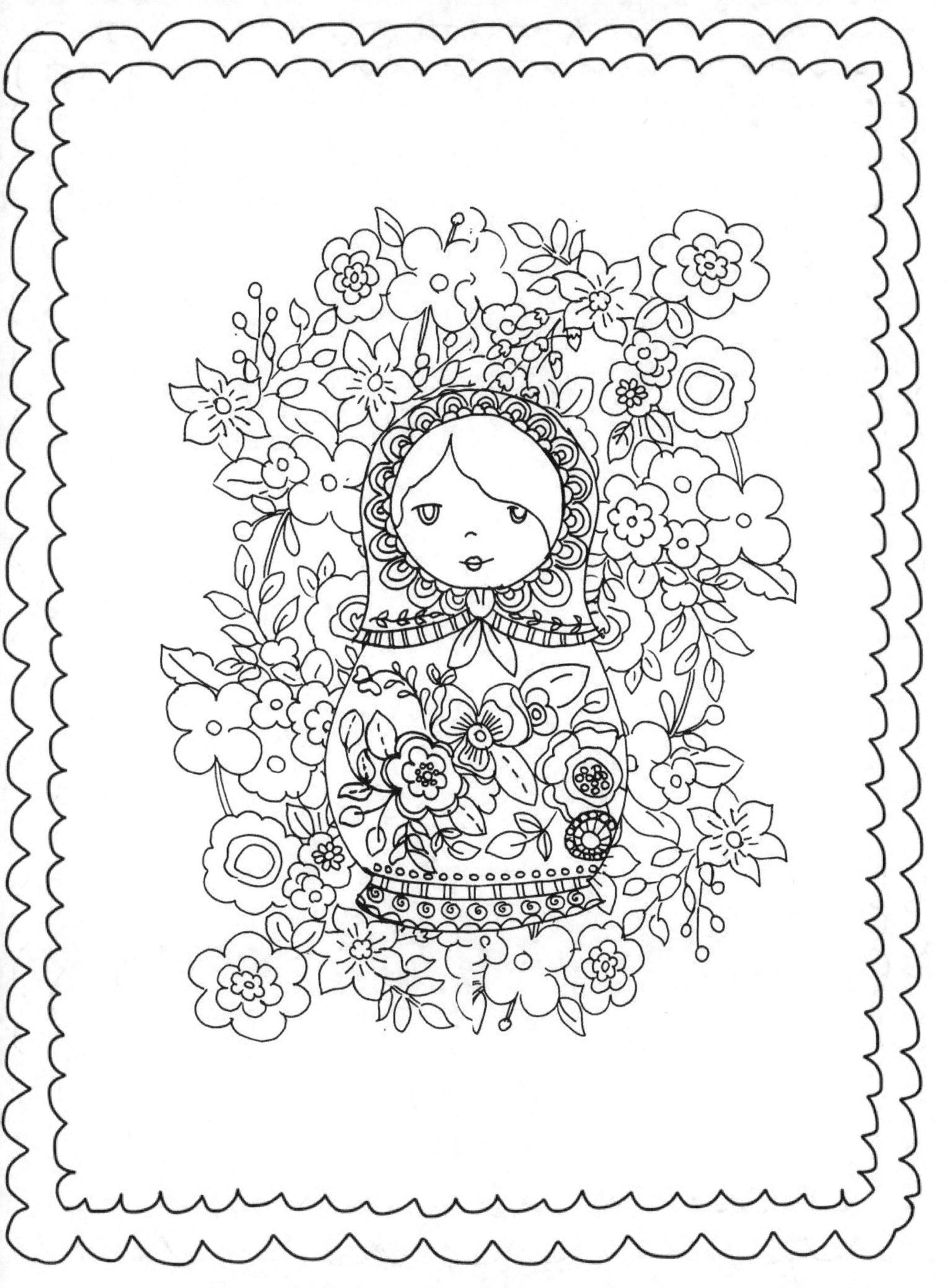

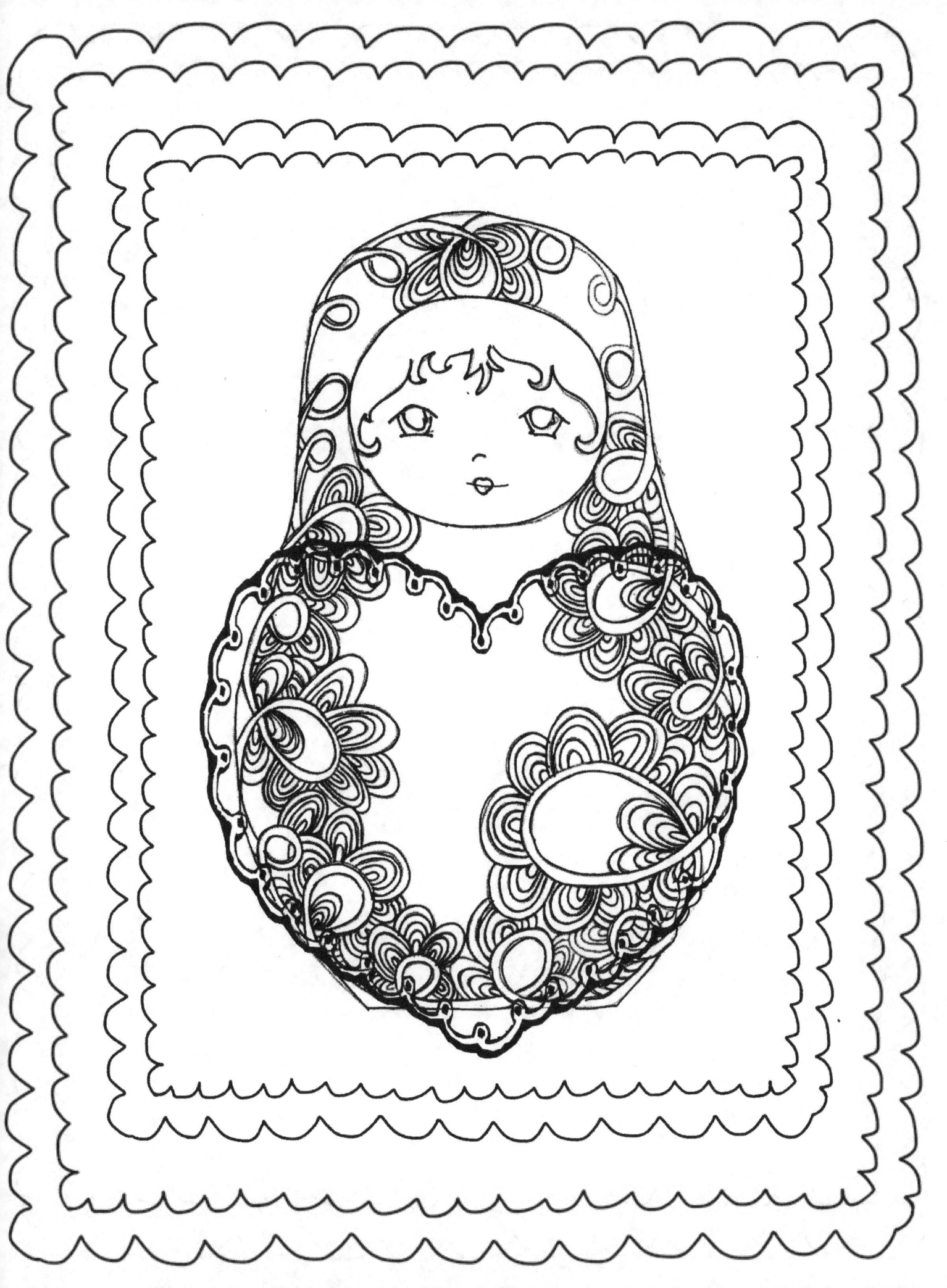

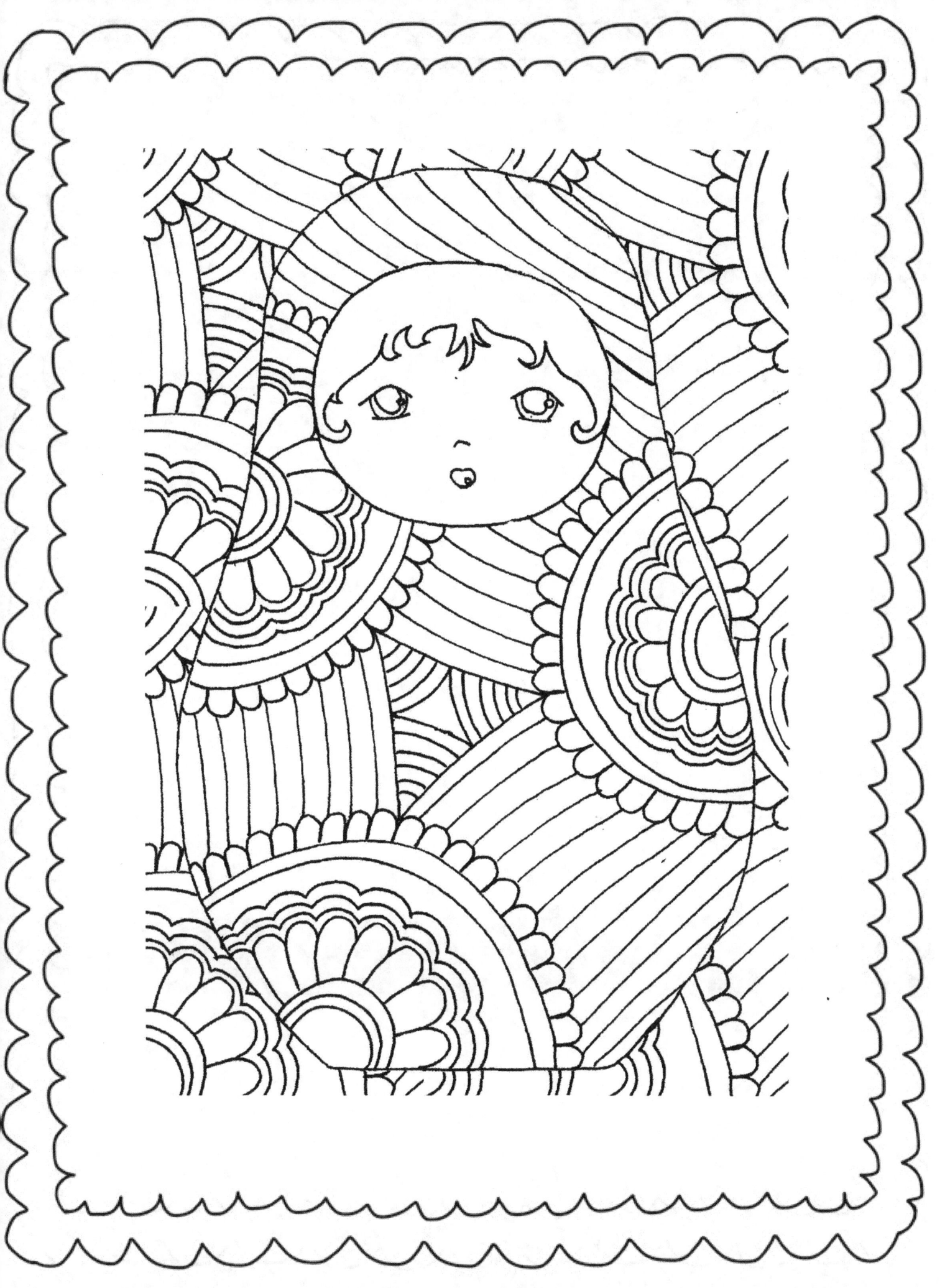

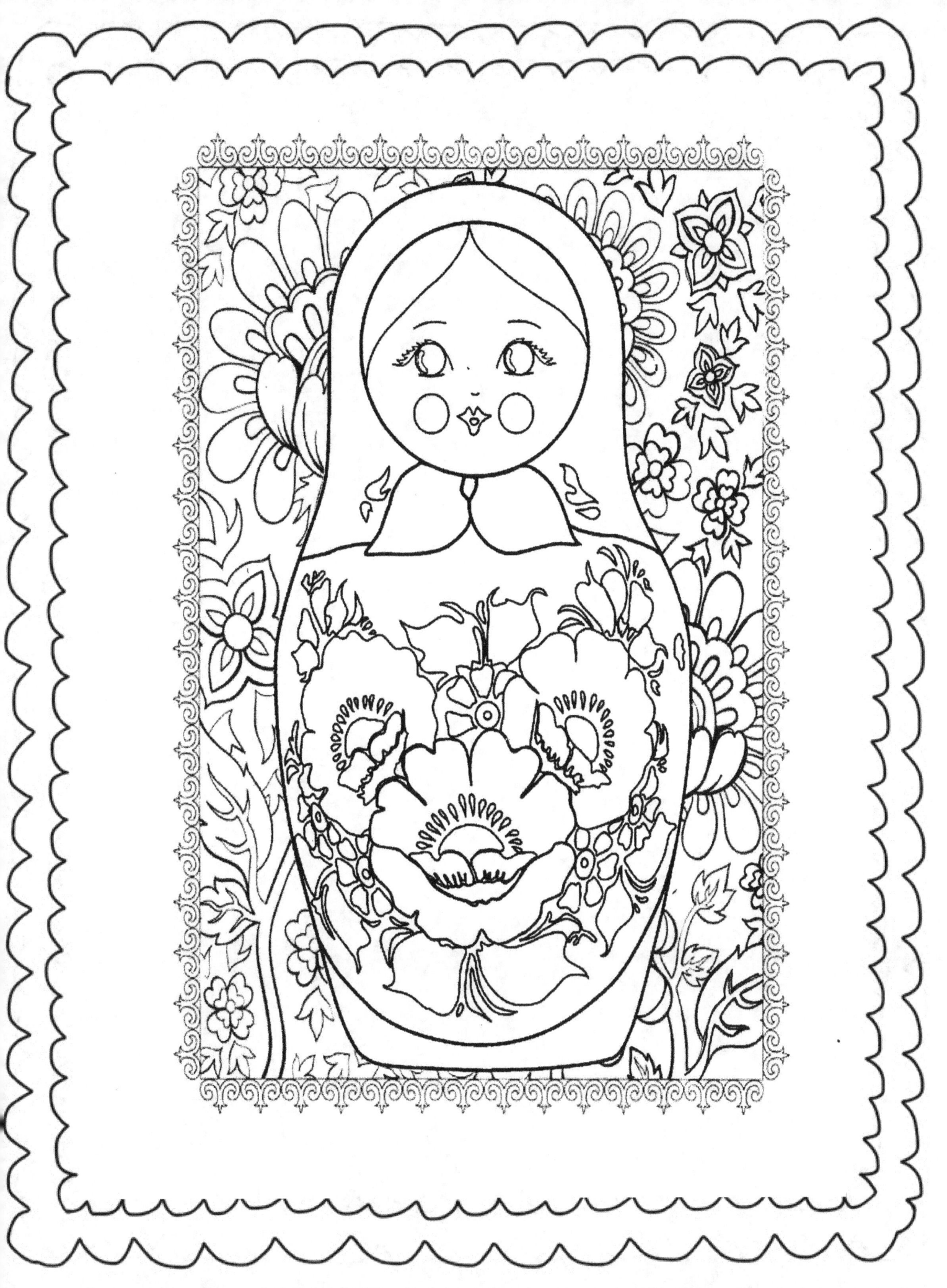

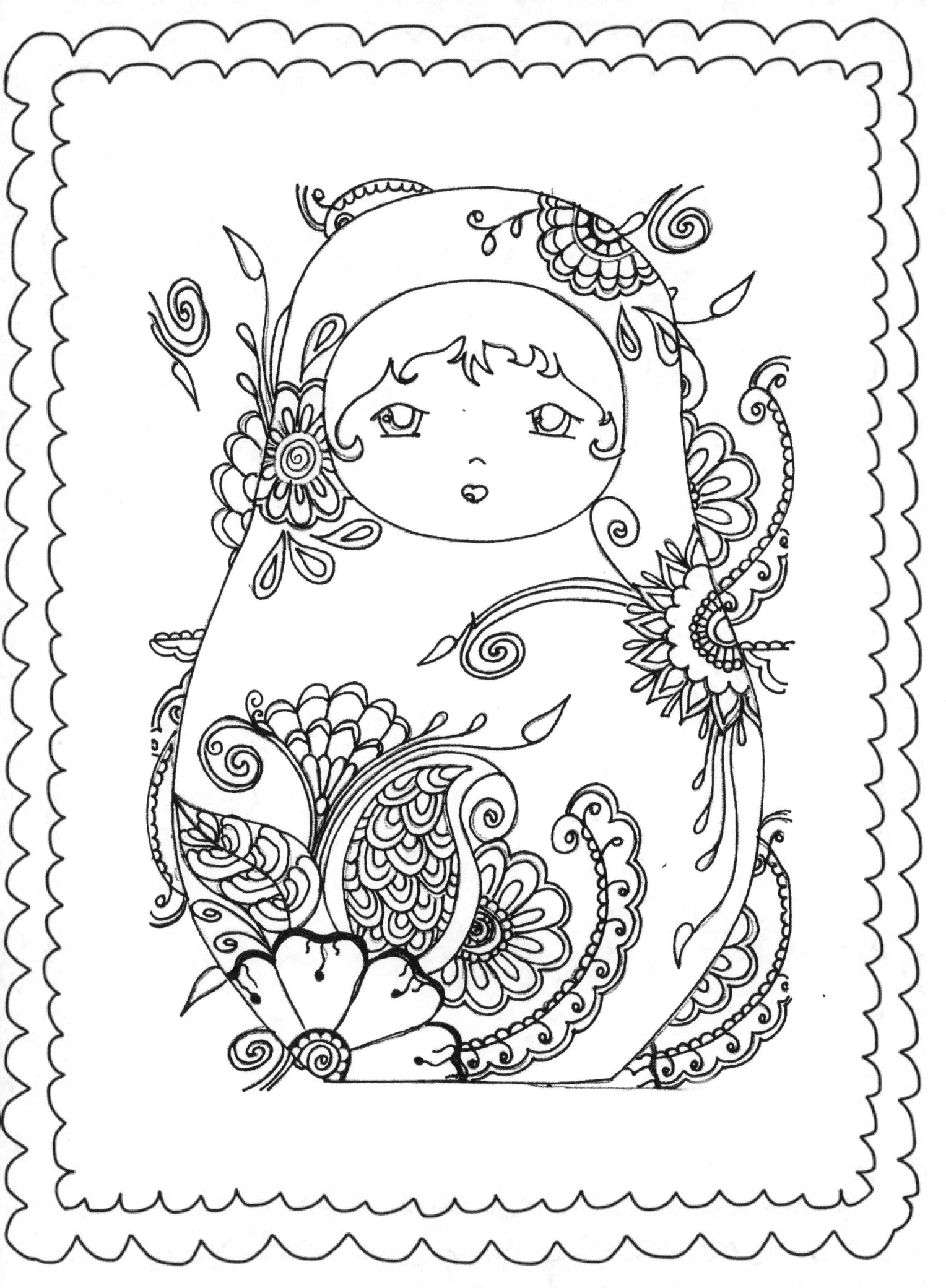

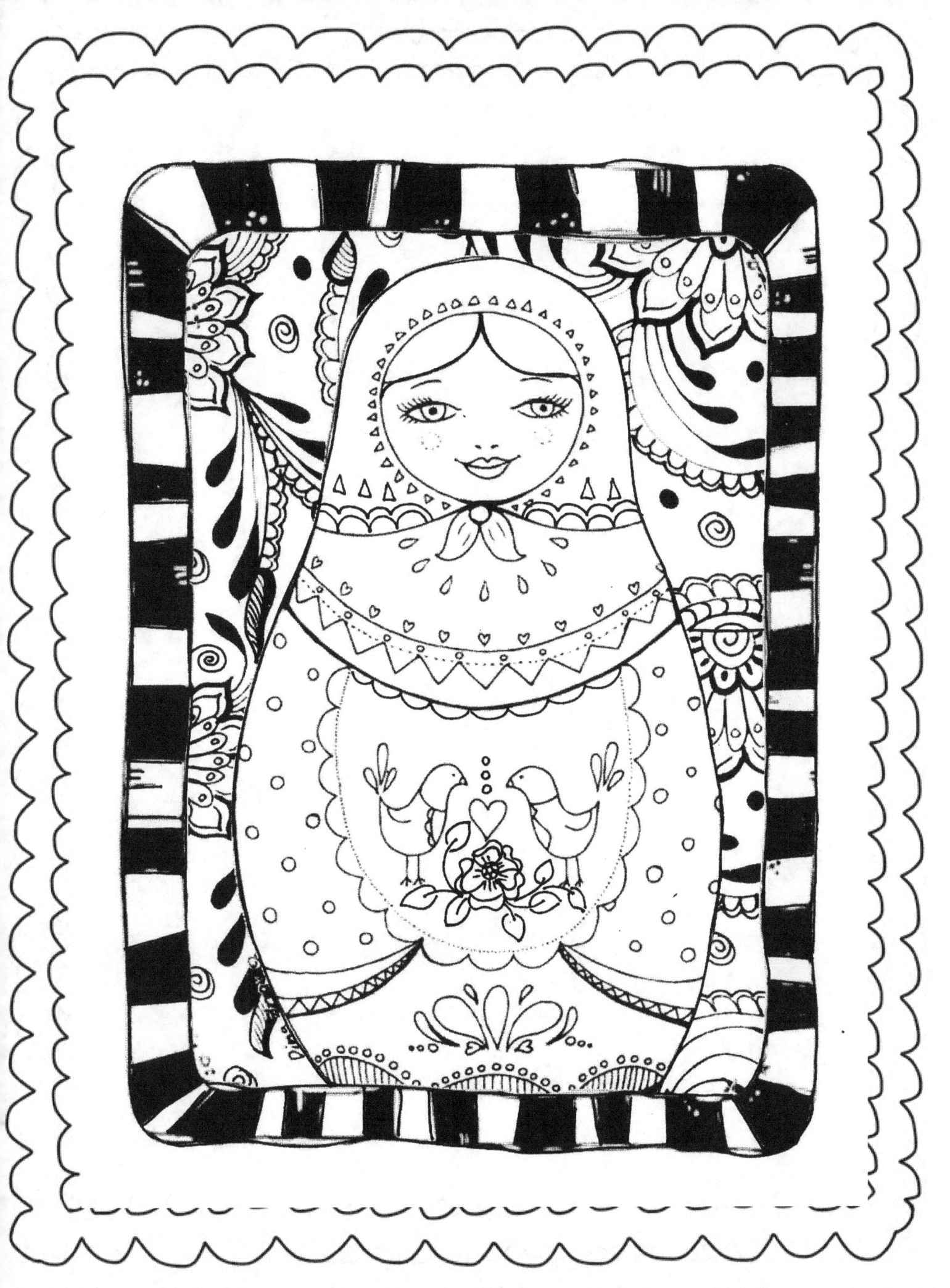

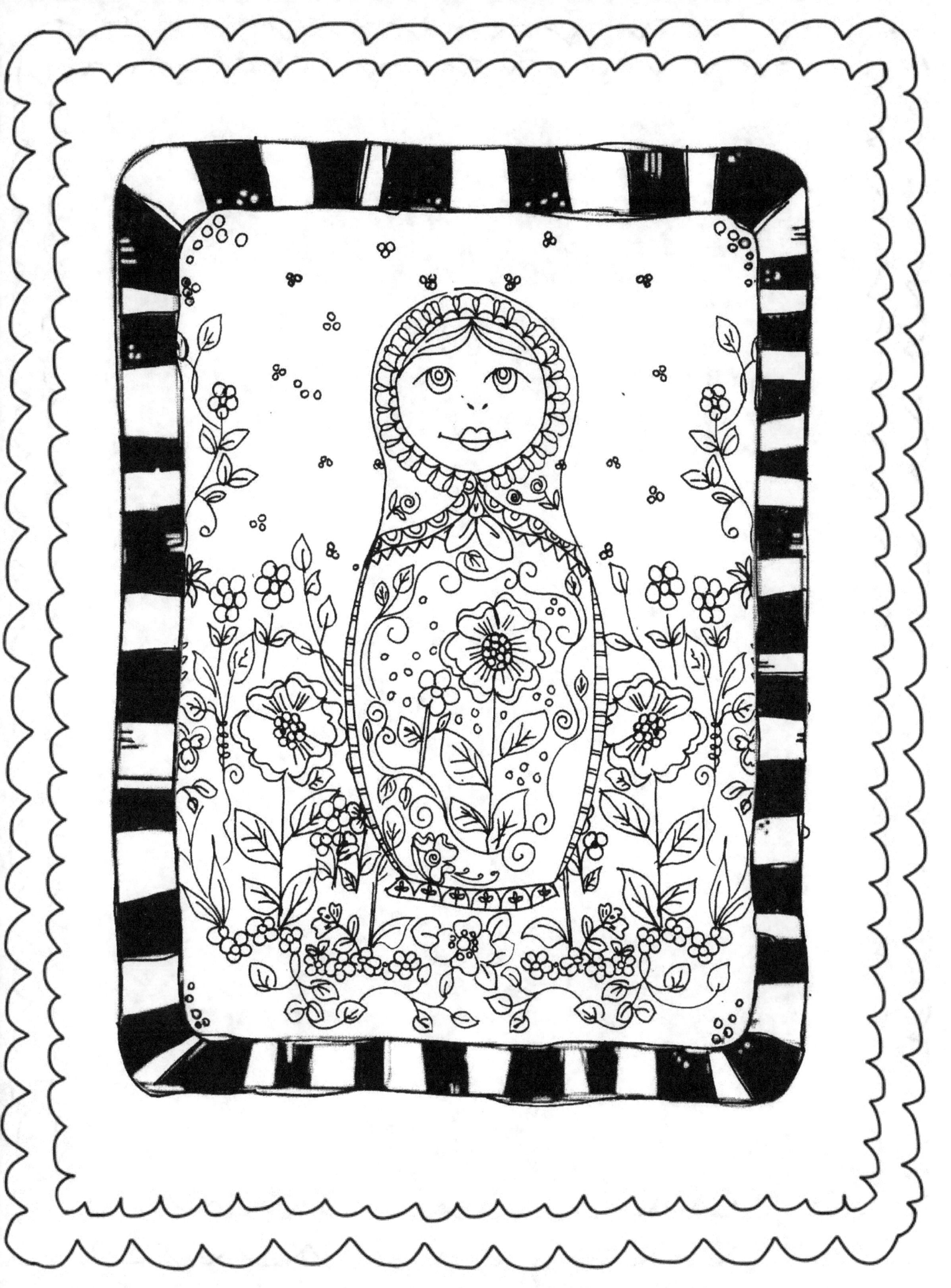

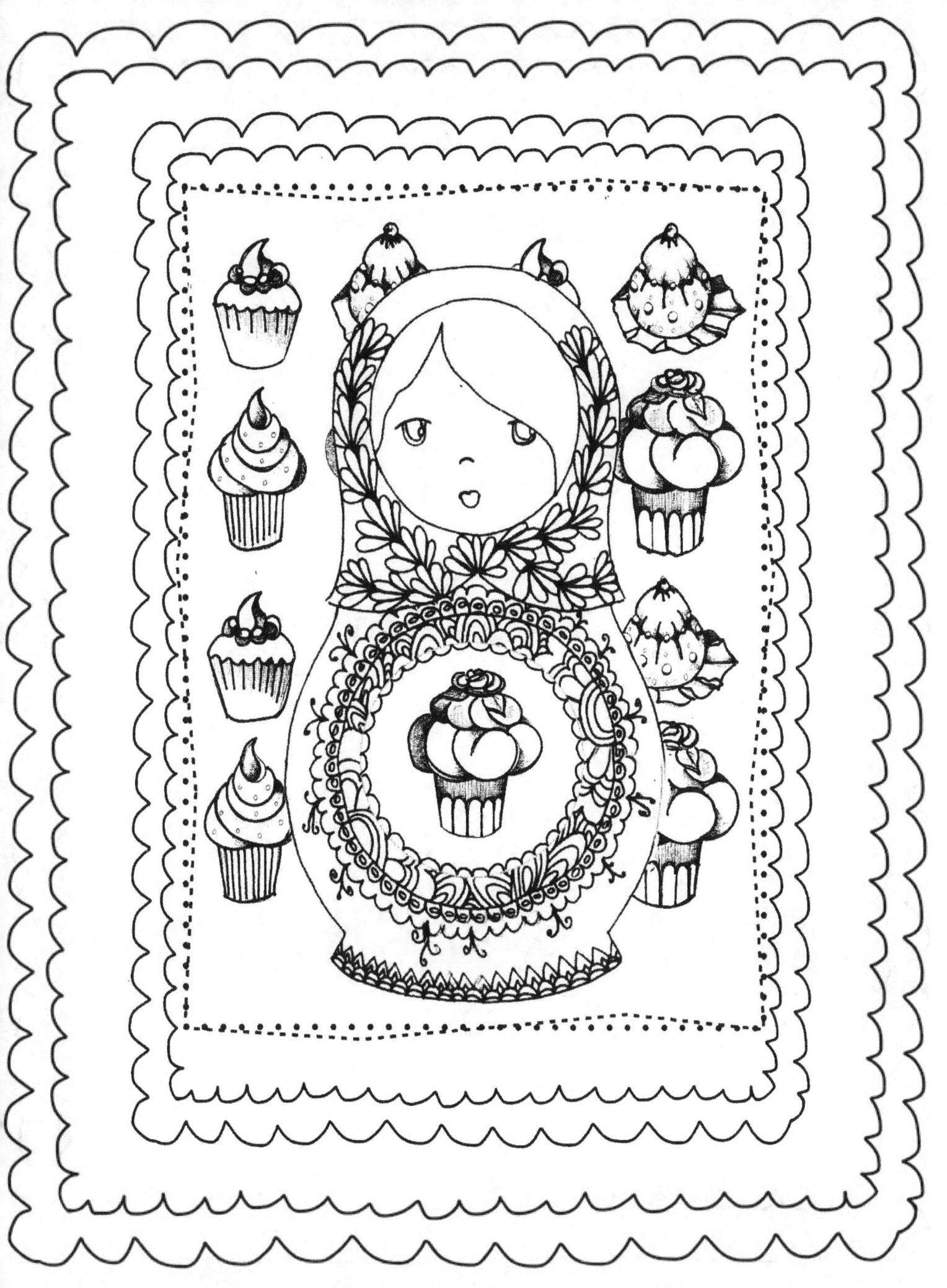

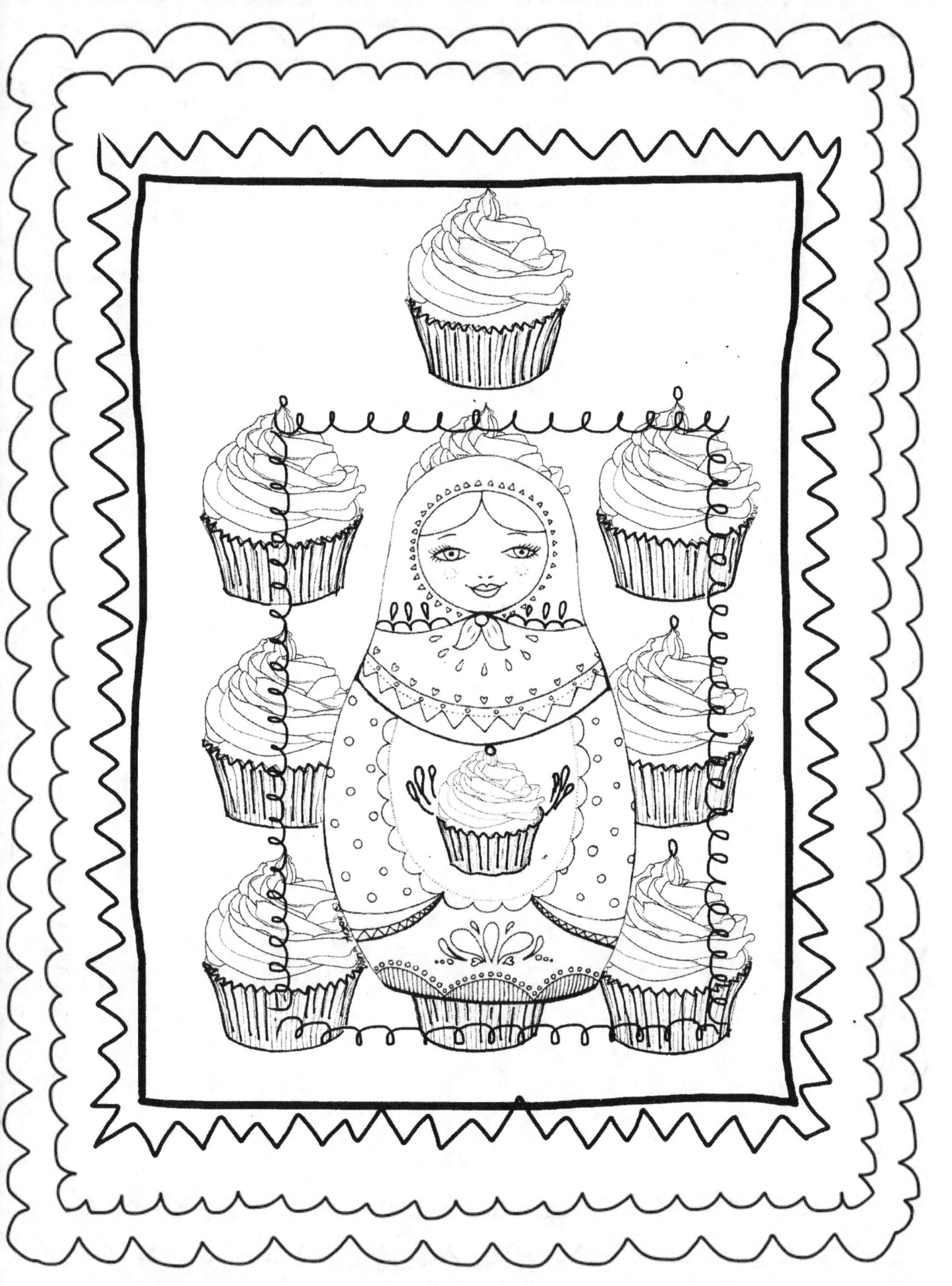

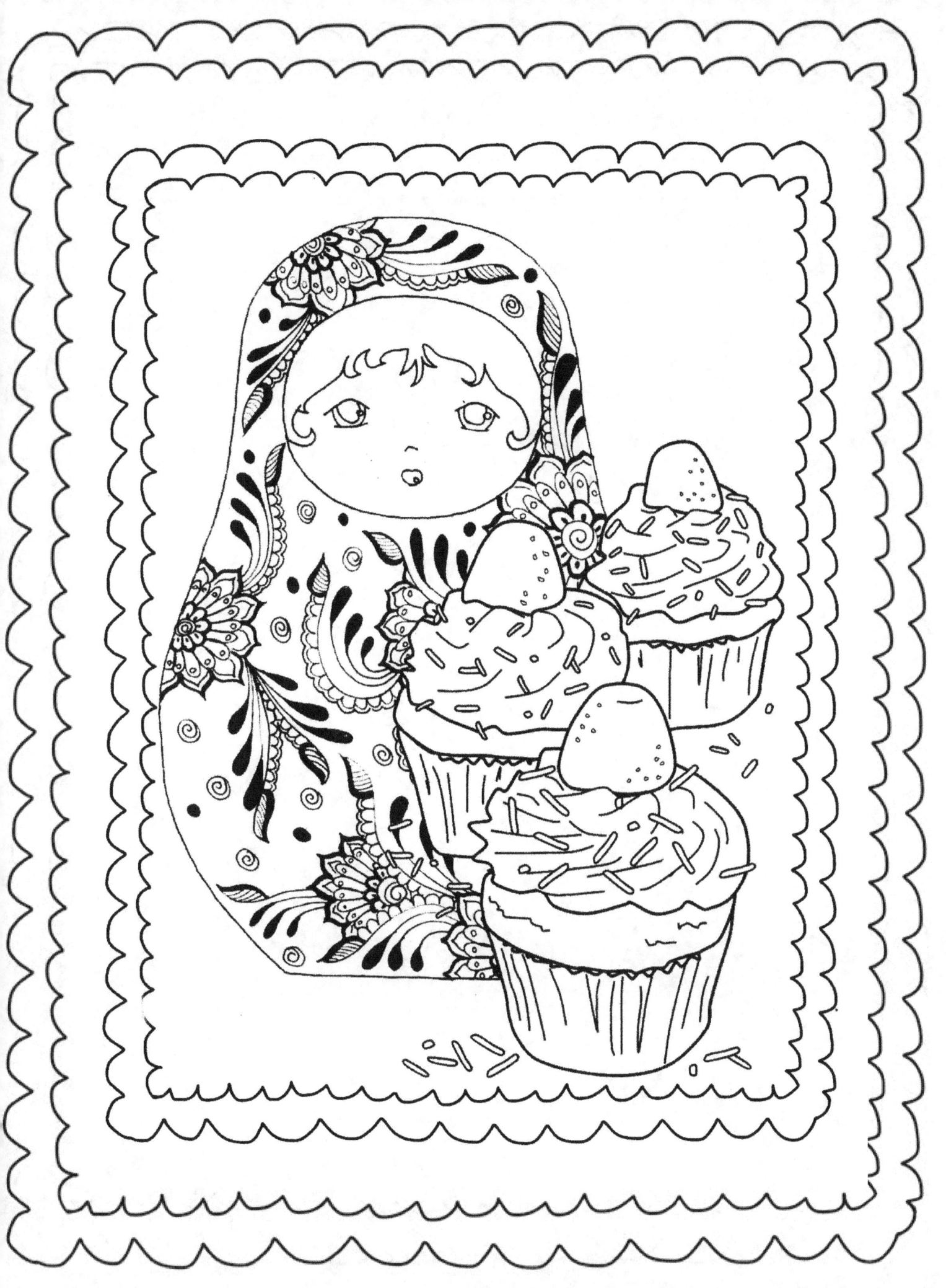

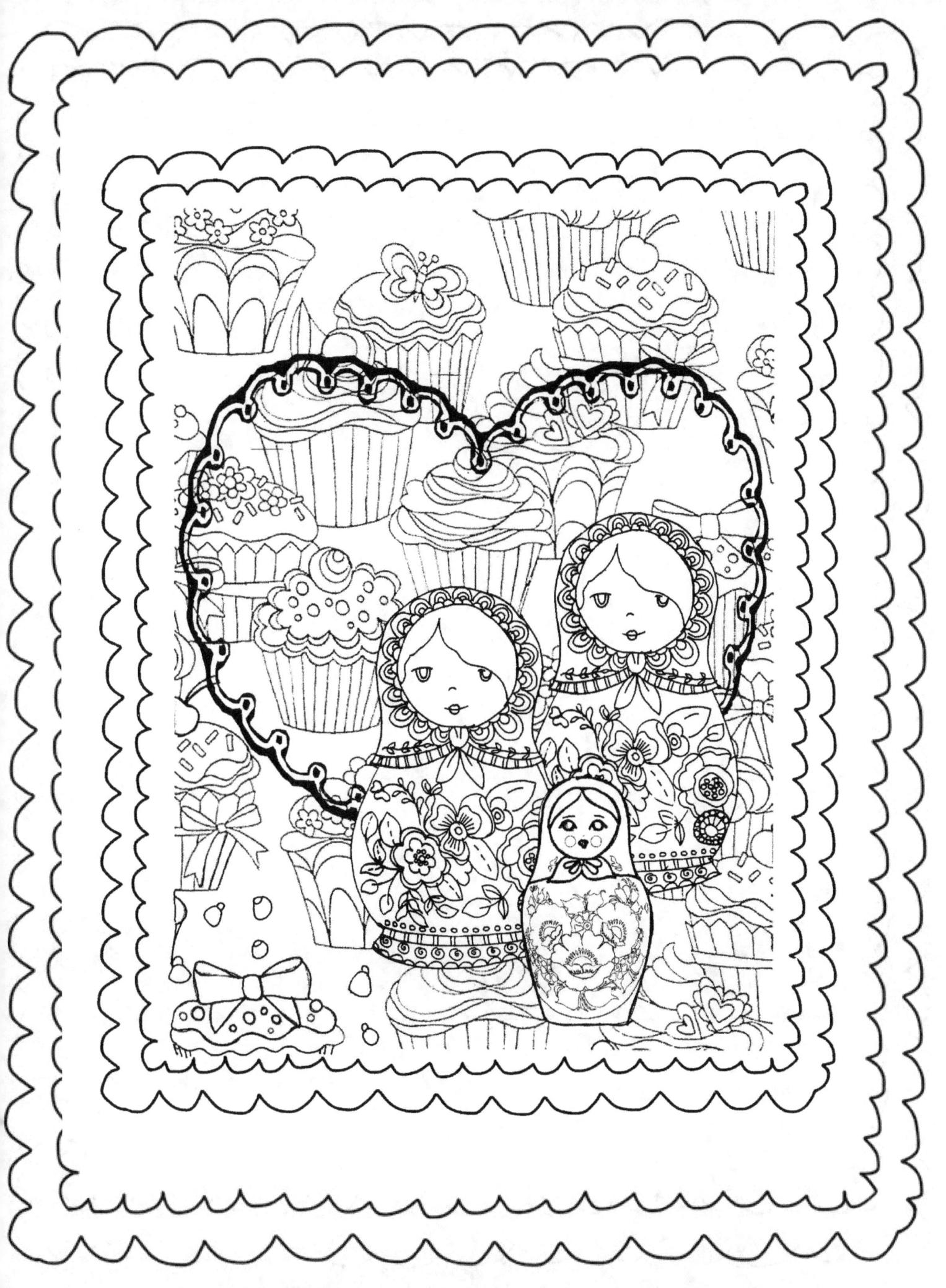

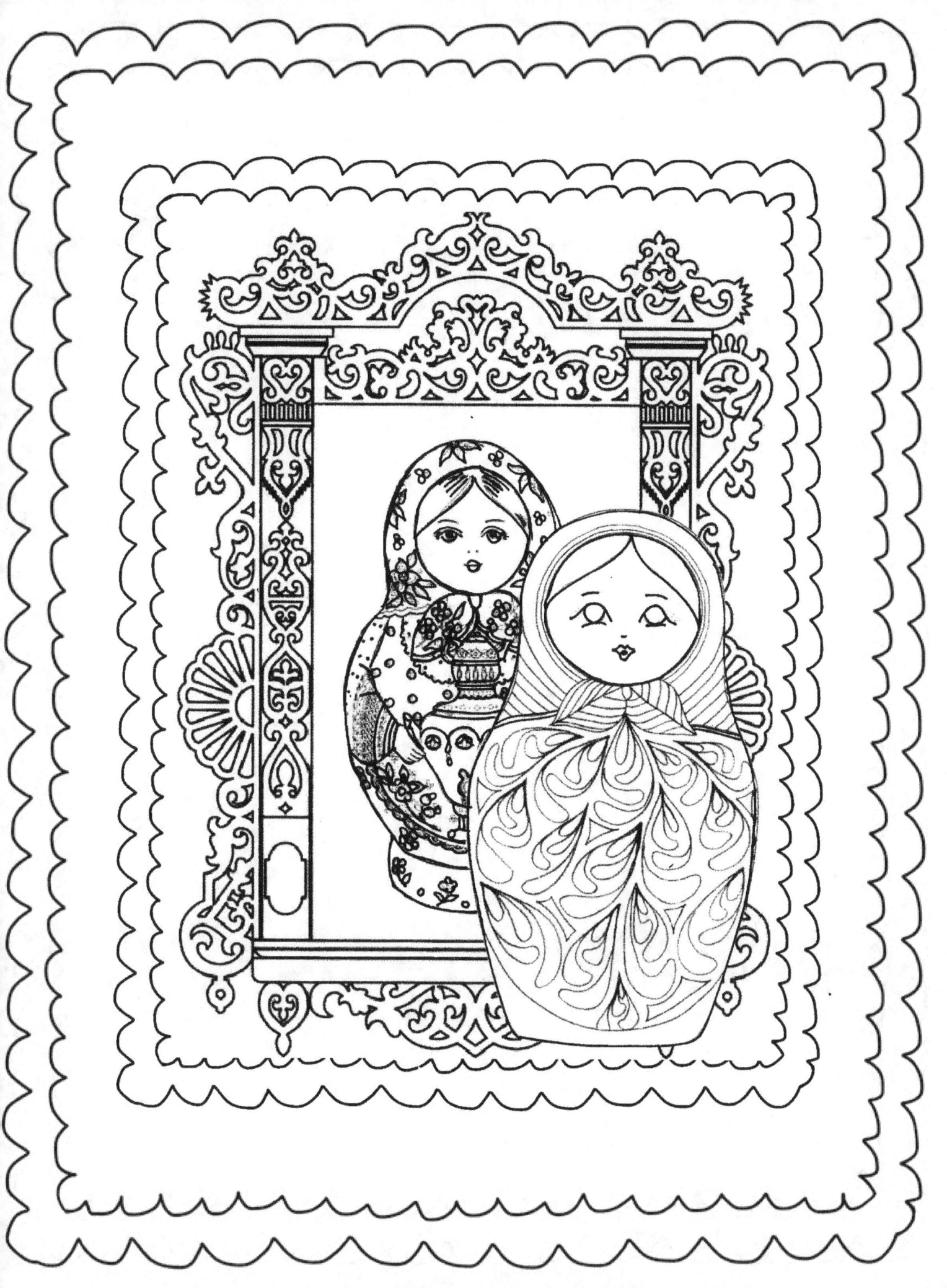

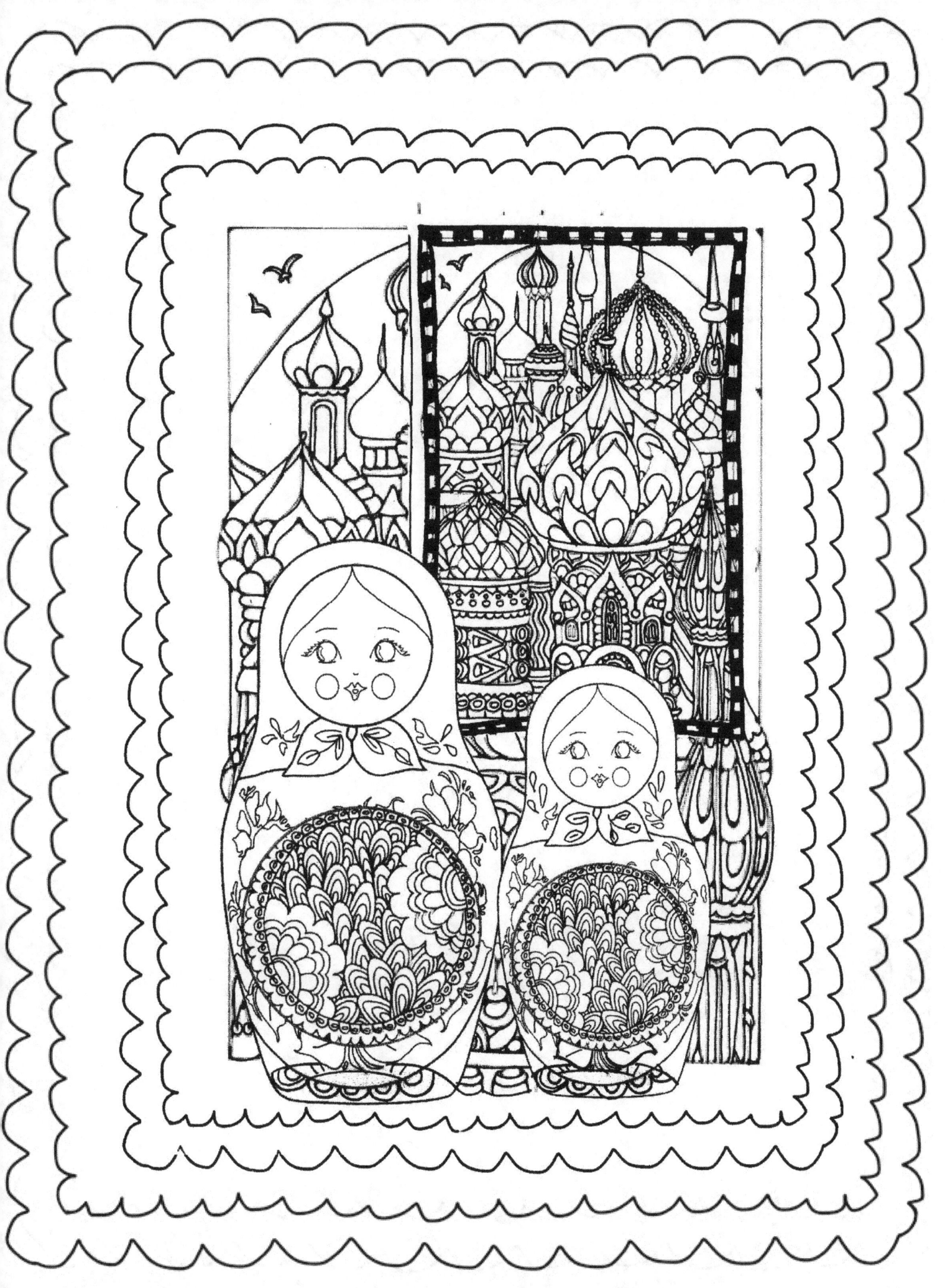

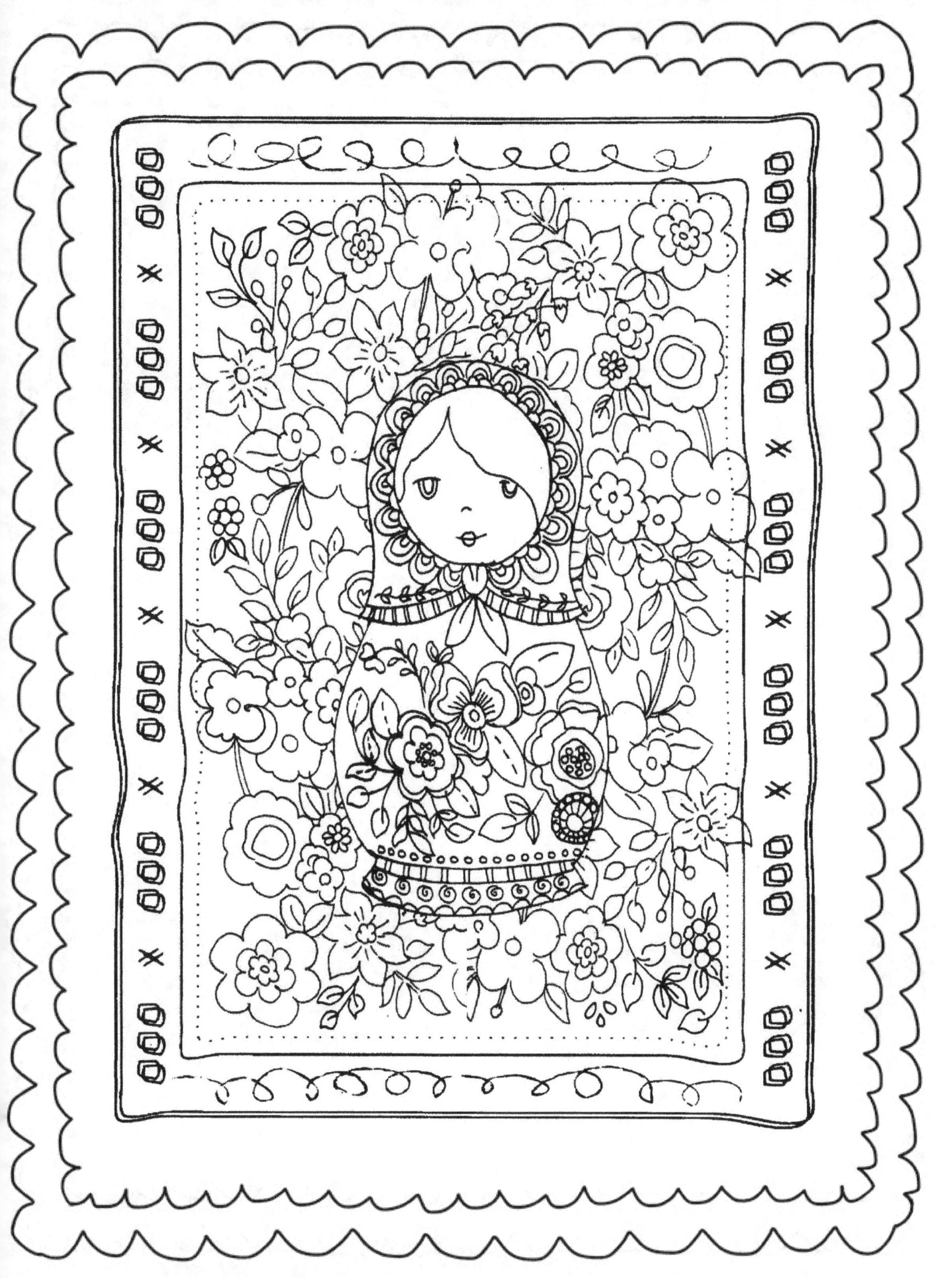

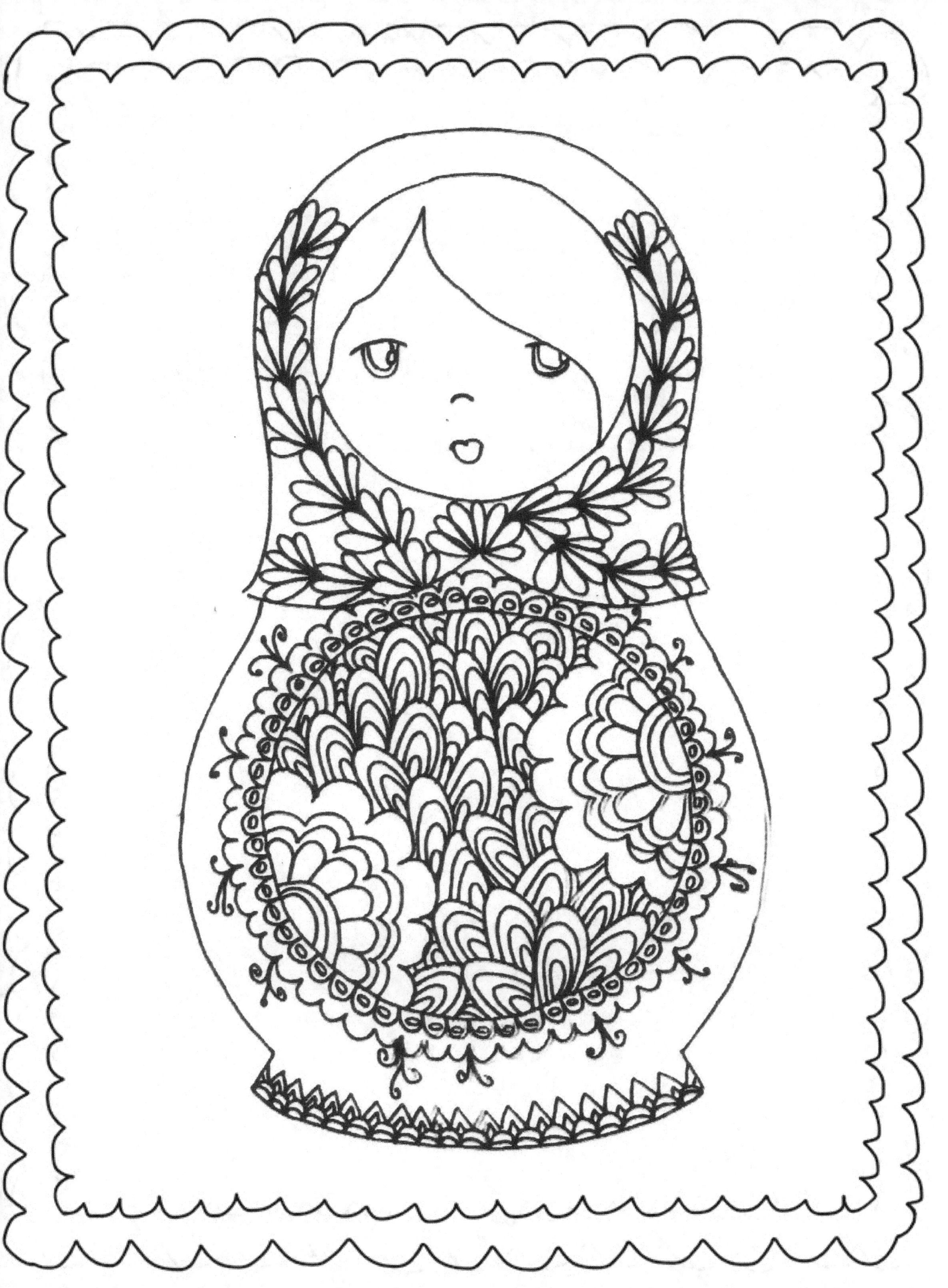

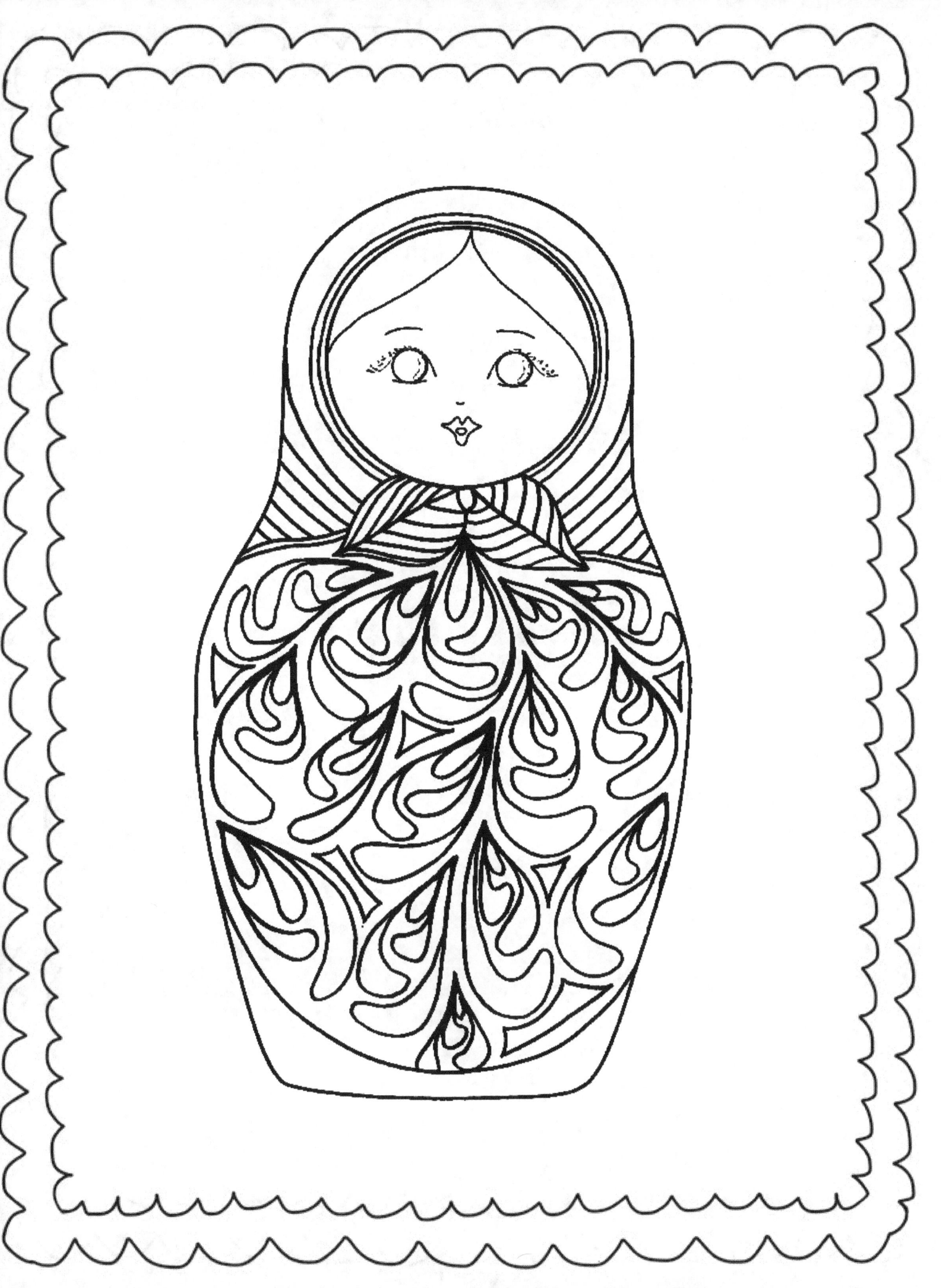

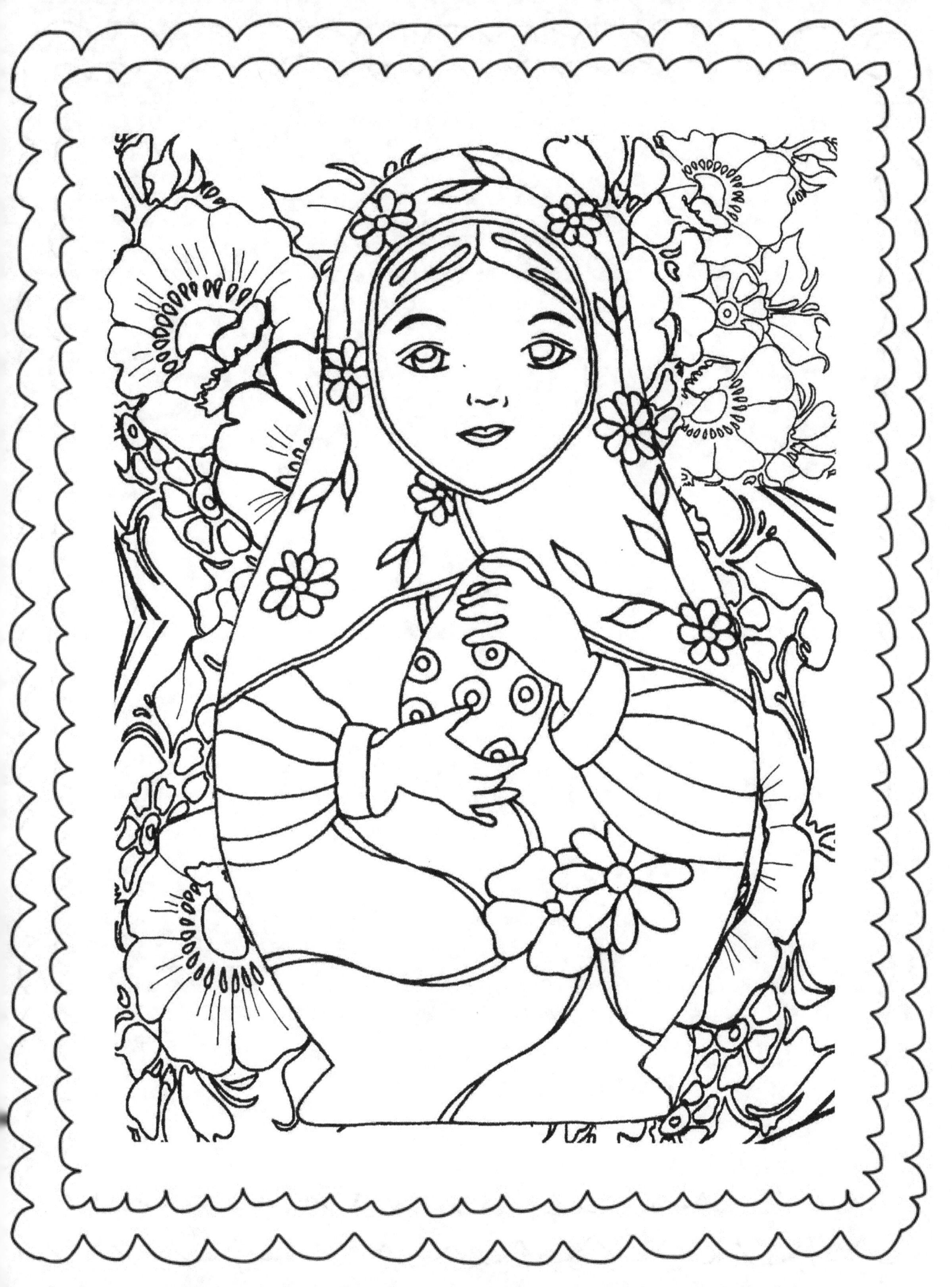

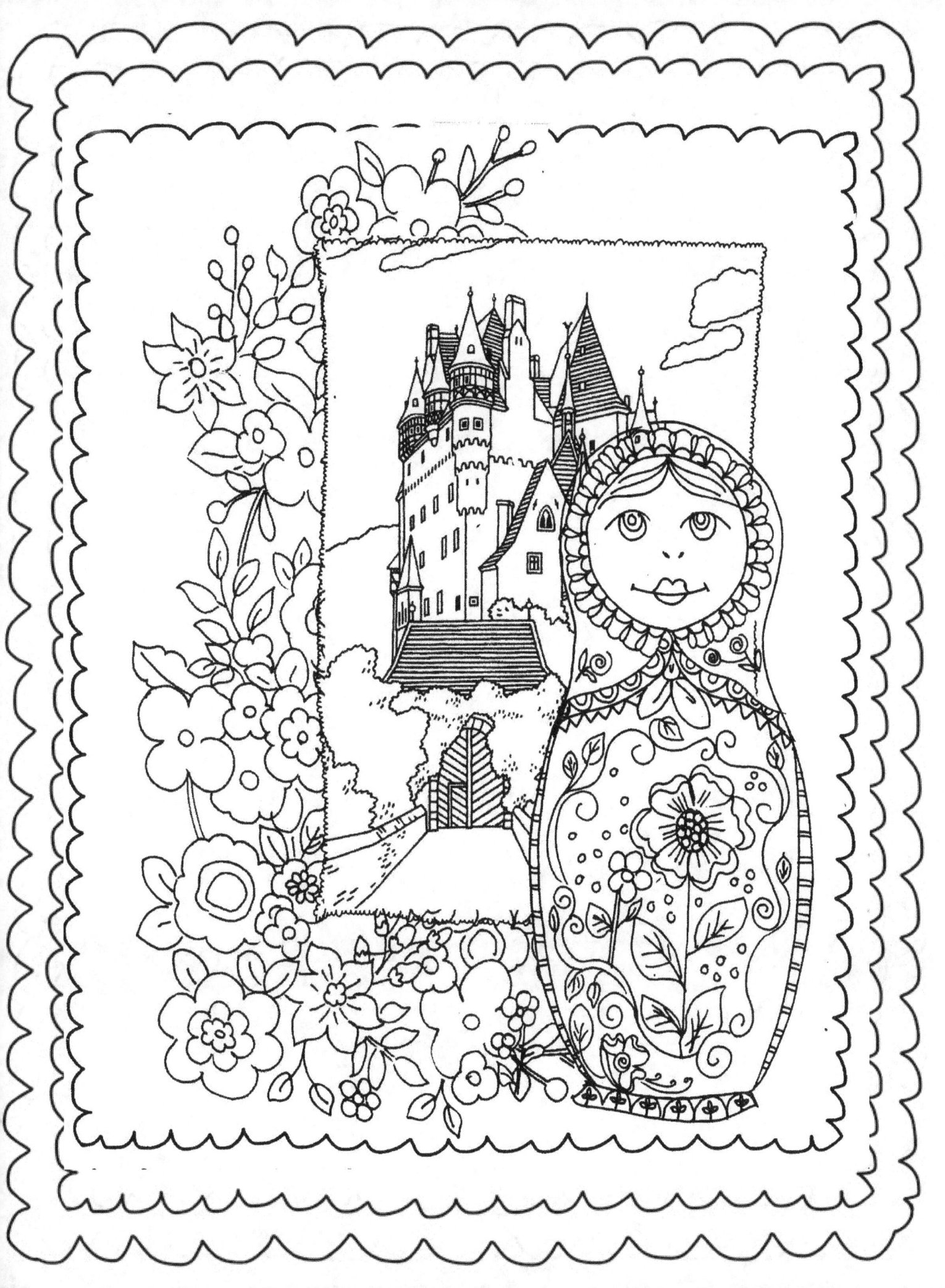

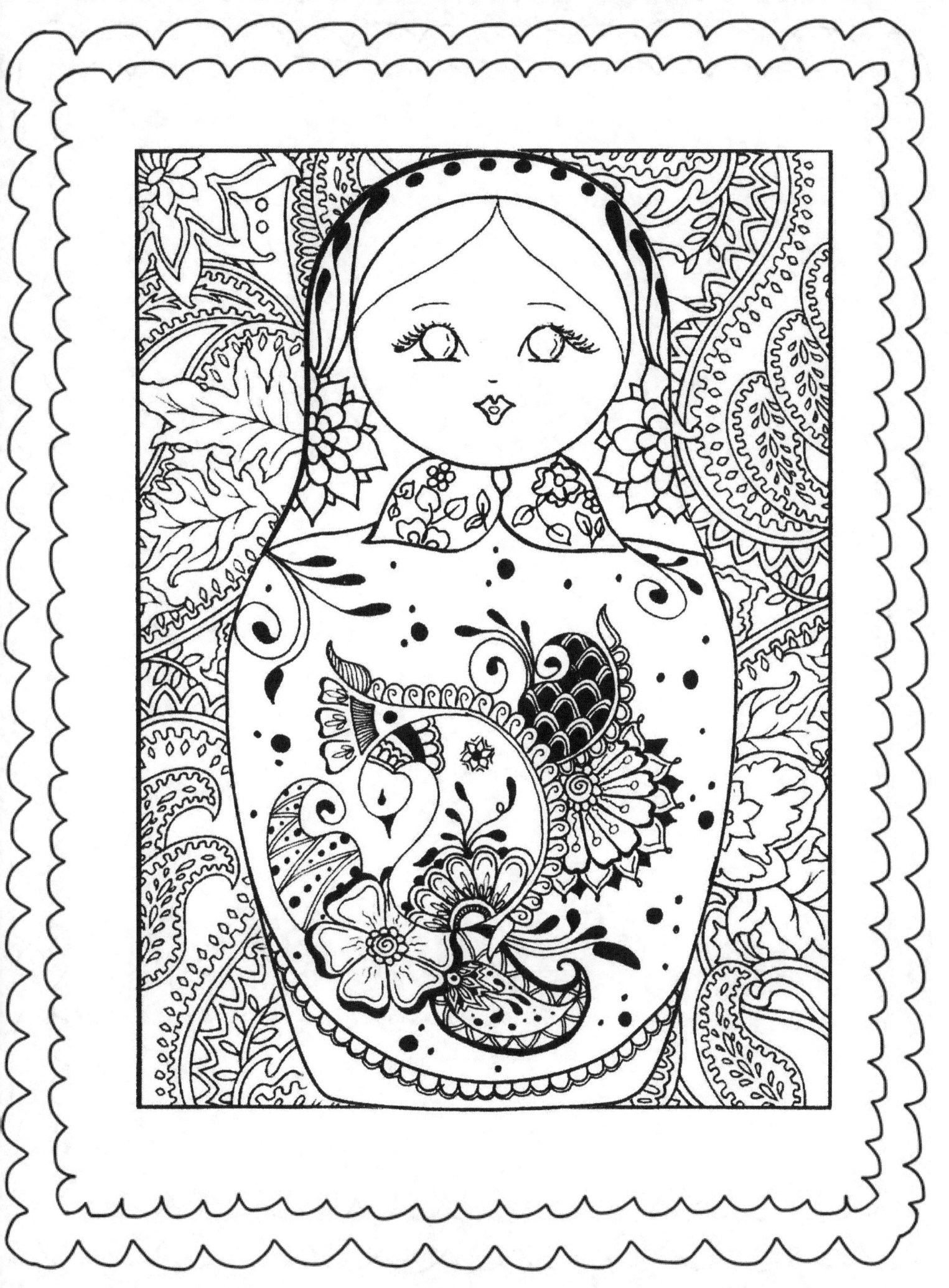

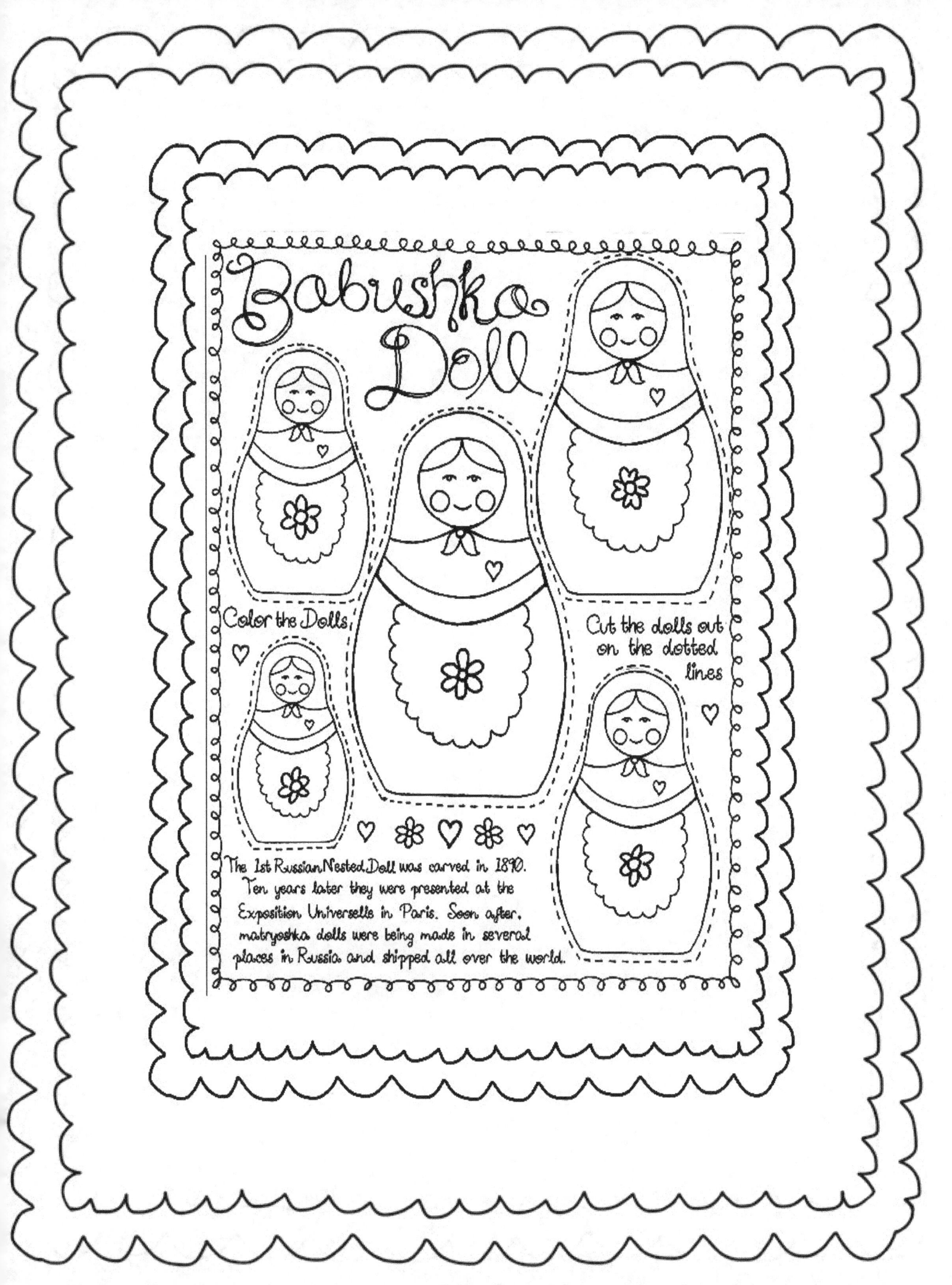

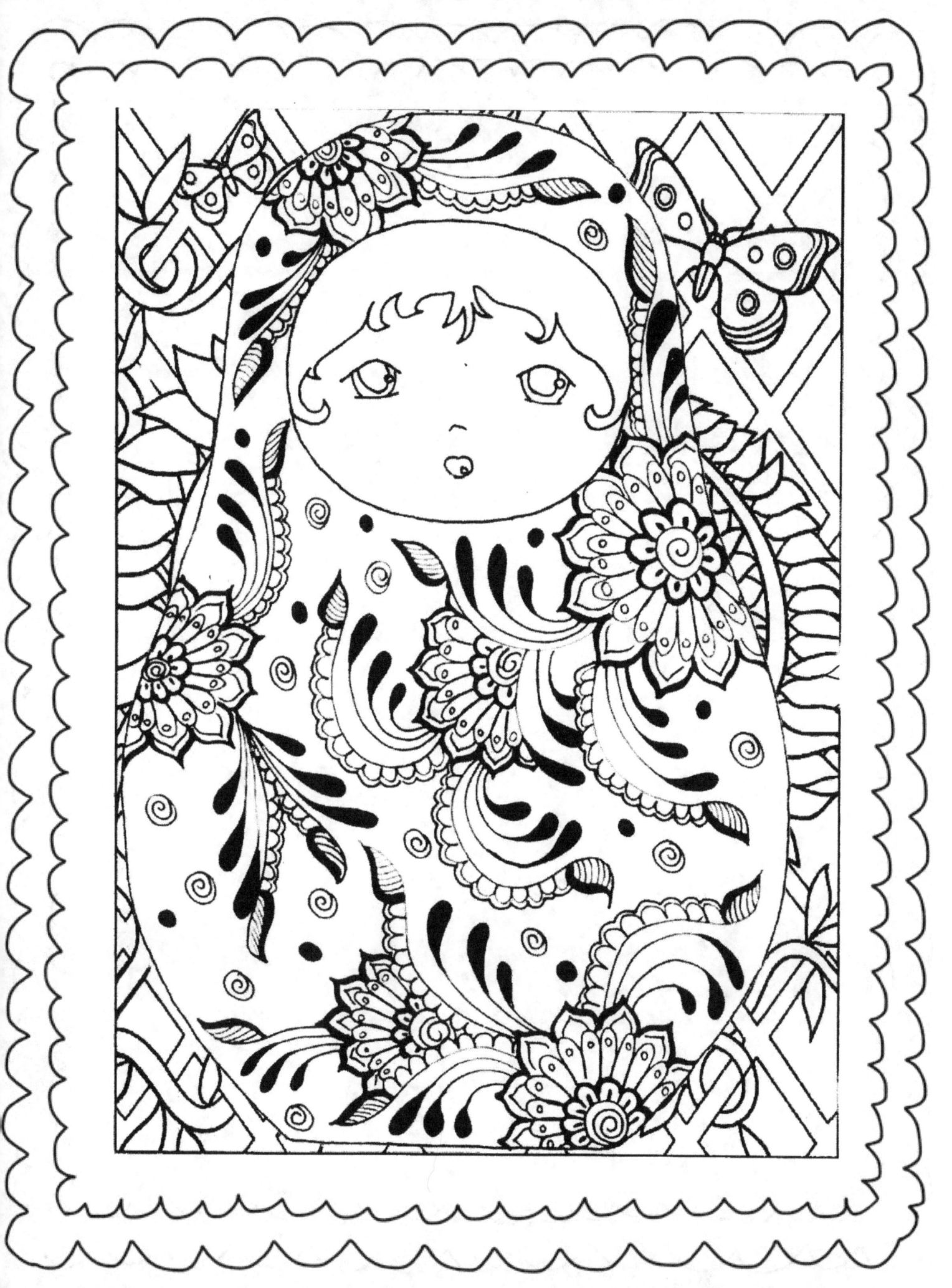

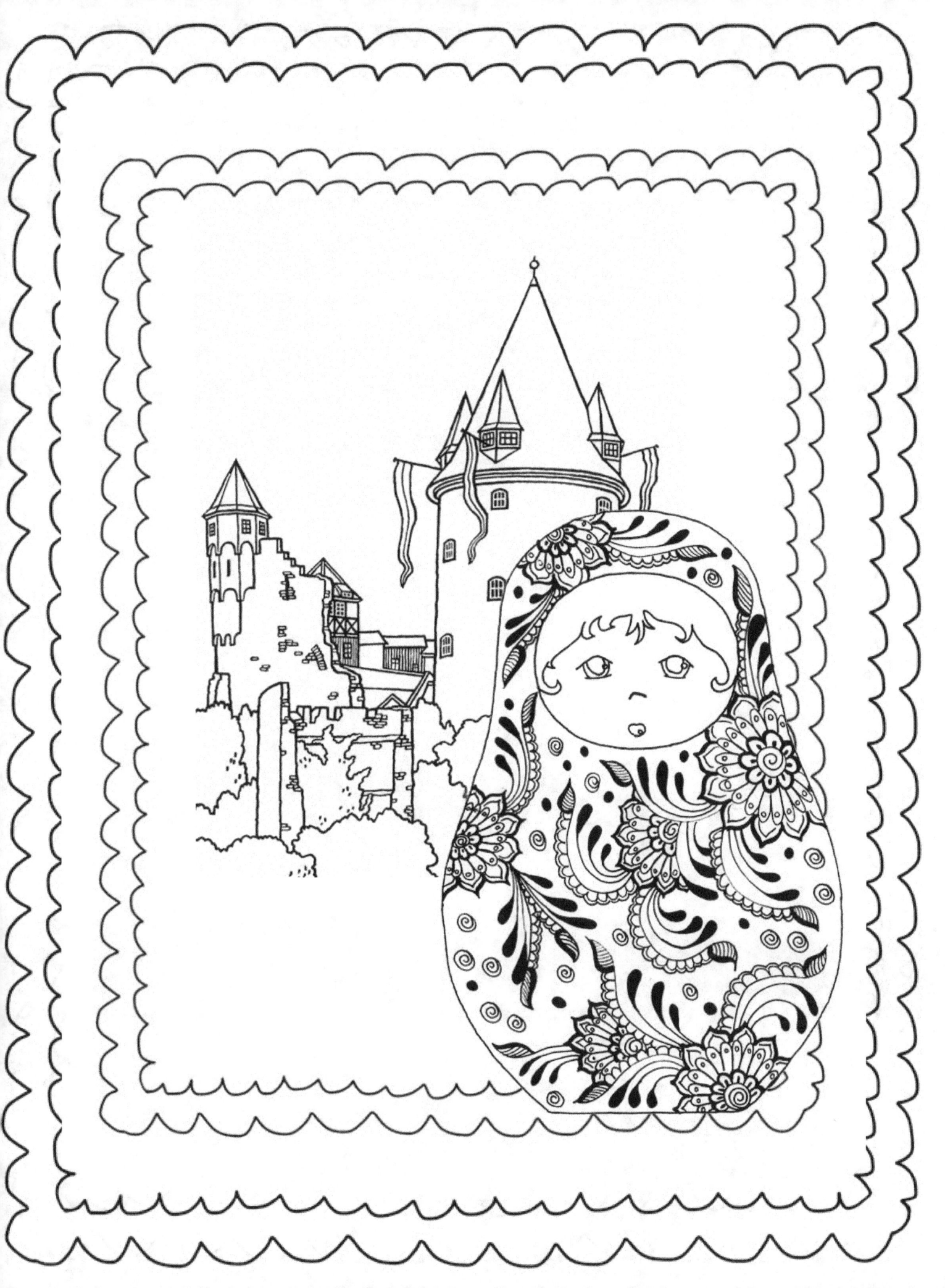